# VIETNAM

# REMEMBERED

**Also in this series**

*The Holiday Yards of Florencio Morales: "El Hombre de las Banderas"* by Amy V. Kitchener

*Santería Garments and Altars: Speaking without a Voice* by Ysamur Flores Peña and Roberta J. Evanchuk

*Punk and Neo-Tribal Body Art* by Daniel Wojcik

*Chainsaw Sculptor: The Art of J. Chester "Skip" Armstrong* by Sharon R. Sherman

*Sew to Speak: The Fabric Art of Mary Milne* by Linda Pershing

Folk Art and Artists Series
Michael Owen Jones
*General Editor*

Books in this series focus on the work of informally trained or self-taught artists rooted in regional, occupational, ethnic, racial, or gender-specific traditions. Authors explore the influence of artists' experiences and aesthetic values upon the art they create, the process of creation, and the cultural traditions that served as inspiration or personal resource. The wide range of art forms featured in this series reveals the importance of aesthetic expression in our daily lives and gives striking testimony to the richness and vitality of art and tradition in the modern world.

# VIETNAM

# REMEMBERED

## THE FOLK ART OF MARINE COMBAT
## VETERAN MICHAEL D. COUSINO, SR.

Varick A. Chittenden

Photographs by Martha Cooper

University Press of Mississippi    Jackson

*We dedicate this book*
*to those Vietnam veterans who served, to*
*those who never came back, and to those who*
*are still serving today;*
*to Patti, Michelle, Michael, and Matthew*
*and to Judy,*
*for their love, patience and understanding,*
*while we told these stories of war and peace.*

*—MDC & VAC*

Photo credits: Varick A. Chittenden/TAUNY, figure 8; unidentified photographer, figure 2; all other photographs by Martha Cooper.

Copyright © 1995 by the University Press of Mississippi
All photography copyrights belong to the individual photographer.

*Library of Congress Cataloging-in-Publication Data*

Chittenden, Varick.
 Vietnam remembered: the folk art of marine combat veteran Michael D. Cousino, Sr. / Varick A. Chittenden; photographs by Martha Cooper.
  p.    cm. — (Folk art and artists series)
 Includes bibliographical references.

 ISBN: 978-1-61703-215-8

 1. Cousino, Michael D. — Themes, motives.
 2. Military miniatures — United States.
 3. Outsider art — United States.
 4. Vietnamese Conflict, 1961-1975 —
 Art and conflict I. Cooper, Martha. II. Title.
 III. Series.
 NK8473.5.C68C55   1995              95-13654
 745.592'82'092 — dc20                    CIP

*British Library Cataloging-in-Publication data available*

# CONTENTS

Preface 5

The Folk Art of Marine Combat
Veteran Michael D. Cousino, Sr. 9

References 35

Color Plates 37

A SMALL feature article in the local newspaper in 1984 grabbed my attention. The headline read: "Vietnam Vet Uses Artworks to Help Heal Personal Battle Scars." I had been researching folk art and folk culture in the northern counties of New York State for ten years and, by then, I had learned to watch and listen carefully for leads to new and interesting sources. The story went on briefly to describe Michael Cousino, his life in the military, and his first efforts at re-creating stories and experiences in small scale. At the time he had eighteen models finished and plans for a few more. I clipped the article and filed it for future reference.

Nearly two years later, I ran across the piece and decided to call him. I asked if I could come over to talk and to see some of his work. Our first meeting was interesting. While he seemed a little skeptical and guarded about my questions, it was clear that he was passionate about his stories and thoroughly committed to sharing them with others. Surprisingly, our paths had crossed twenty years before. My first teaching job was in the English department at the high school in Gouverneur, New York, when Mike was a student. I did not remember him. Although he had not been in my classes, we discovered that I knew some of his friends and family. When I later checked the school yearbooks for those years, there he was!

When Mike went off to the Marines and then to Vietnam, I stayed on to teach in his hometown. There was a teacher shortage at the time, particularly in economically depressed districts like Gouverneur. For that I received a military deferment. While I had been raised in a committed, small-town, conservative political environment, the national policies of the late 1960s began to open my eyes. Like millions of others, I became dismayed at the politics of the Vietnam conflict. I never protested in public, but I worked in party politics to bring about change. My efforts were thwarted, by party leaders and by elections. I watched young men from my classes go off to war; I got letters from former students in the unimaginable jungle, a long way from home. Their stories distressed me very much. To this day, I am not sure what I would have done if I had been drafted.

What Mike pulled out to show me that day was unforgettable. From various cardboard boxes, stored randomly in all kinds of hidden spaces in the small mobile home, came pieces in all sizes. The images were varied: scorched and melted plastic models; paper palm trees and painted moss; glued dirt and toothpick structures; dismembered, impaled and bloodied human forms. I didn't know how to react. But we talked for hours. Little by little, some of the stories behind these scenes unfolded. By the time I left him late that night, I knew he was the real thing. It was

clear that he and those of his community of veterans with similar experiences and values shared folklore—language, dress, music, narratives—all their own, even though they were scattered, isolated from each other, educated, and immersed in the popular culture of twentieth-century life.

The story that emerges in the pages of this book is, in part, about some of the things Mike and I have done together in the years since that first meeting. With numerous exhibits of his work, the classroom and public lectures he has given, the published articles and other public forums about him, he has grown personally and artistically. He is now confident in presenting himself and his stories. He is more objective about his own experiences and more inclusive of others'. While he always wants his scenes to help others better understand the Vietnam experience, his mission and his approach are now more characteristic of a historian than of a therapist. Absolute accuracy and thoroughness are never sacrificed to art. Still, the refinements of his more recent works make them seem even more energetic and artful than his early pieces.

In his career as an exhibited artist, Mike has found new audiences. In addition to the Vietnam veterans who really know what he is talking about, I and hundreds of others like me who had doubts about or objections to that war have found his work to be dramatic and revealing. From his work and his stories we can begin to feel how the ordinary soldier felt in the throes of combat and in the face of controversy and rejection when she or he came home. While the passing of time has helped the nation to heal, those of us who lived through the trauma of Vietnam are still learning that healing also takes effort. Seeing his work and hearing the stories can help us all.

I am, of course, greatly indebted to Mike Cousino for the hours and days that he has shared with me, for his talk about the work as he prepared—and repaired—it for exhibitions and photography, for his patient explanations of military terms and materials, for his many acts of friendship.

I am grateful to Ernie Amabile, Elizabeth Kahn, Nellie Coakley and Michael McCurdy for their personal observations and comments on Mike and his work.

I wish to thank Martha Cooper for her outstanding photography, her commitment to excellence, and her enduring interest in Mike and other artists with whom we have worked on projects for Traditional Arts in Upstate New York (TAUNY), the regional folk arts organization.

I also very much appreciate the help and encouragement given in the early stages of this book project by Lydia Fish, Professor of Anthropology at SUNY Buffalo and founder/director of the Vietnam Veterans Oral History and Folklore Project, and by Bruce Jackson, former editor of the *Journal of American Folklore*.

And I especially thank Michael Owen Jones, editor of this and other books in the Folk Art and Artists Series, for his encouragement and enthusiasm about this work.

I THINK OF my artwork as Vietnam in Retrospect, Looking Back. To most Vietnam veterans it is just like yesterday he or she was in Vietnam. He can still see it, very clear, today. The Vietnam vet will tell me a situation. I'll think about it. It may take a week, two weeks, a year. But I'll build it. And while I'm building this, I go through a variety of emotions myself, because the average Vietnam vet like me wants to forget Vietnam. I go back, to be rejuvenated, so to speak, to get in the mood, so I can create. At times I do go through Hell, a private Hell, which even another vet really doesn't know about. All he sees is his situation that he told me. He'll look at it. He may laugh, he may cry, feel sad, or say, "Hey! I forgot about this shit, man. But it's so goddamn fucking real!" It's hard for them to tell the story, but they want the public to know what happened in Vietnam. And that's basically what I'm doing, telling the public that, Hey! War sucks! There is no good in war. Both sides lose. My scenes must be real to the Vietnam vet when he or she looks at it. And it is. The only thing is, it don't have the sounds, the heat, the smells of the vegetation, whatever. But whatever you see in plastic, dirt, and paint is a story that happened to a Vietnam vet.

United States Marine combat veteran Michael D. Cousino, Sr., of Gouverneur, New York—like many other veterans of the Vietnam conflict—continues to live with bad memories and difficult adjustments. Unlike many others, he has found an outlet for his frustrations and grief: the creation of dozens of miniature dioramas to represent scenes of battle and military experiences from that period in his life nearly thirty years ago (plate 1).

Cousino's scenes, created to a 1-to-35 scale (one inch to thirty-five inches of actual size), are replete with details. The pieces depict firefights (hand-to-hand combat with the enemy), POW camps, torture pits, and ambushes, some noncombat situations, and a few homefront or postwar activities. Having begun to make the scenes in 1983—"to keep from going bonkers when [he] couldn't find a job"—Cousino has now completed nearly two hundred, some of them very complex and many requiring great amounts of time. He claims that no two are alike.

## Cousino as Veteran

In April 1966, Cousino left his little mining and farming village in northernmost New York state where he had lived all of his seventeen and one-half years. The son of a World War II infantryman, he enlisted in the Marine Corps and headed for boot camp at Parris Island, South Carolina. He had never heard of Vietnam. Two years later he was there, serving thirteen months in I Corps in the northern region, Quang Nam province, not far below the Demil-

itarized Zone, or DMZ. While he had trained in supply, he soon realized that he wanted to see more military action. He volunteered for a CAG unit—a Combat Action Group that served as a specialized counterinsurgency force. According to military historian Al Hemingway (1994: x), "they attempted to bring peace to the Vietnamese villages by consolidating the local knowledge of volunteer forces with the professional fighting skills of the Marines."

Cousino spent his tour of duty as a "grunt" (basic infantryman), like most other marines, and served most of his time as a machine gunner and "tunnel rat." Because he was so slender and was used to "country ways," he was often "selected" to explore the elaborate, camouflaged tunnels the Vietcong had built underground. These were frequently big enough to accommodate whole hospitals, supply depots, or training areas. It was an especially dangerous job. Injured in battle in 1969, he spent several weeks in hospitals and was shipped back to the states for physical rehabilitation. Between 1974 and 1983, he lived in several places, mostly in the South, and held various jobs. In 1983 Cousino returned to his hometown after his father's death. The work situation was bleak. For over a year and a half, he, his wife Patti, and three preschool children lived on public assistance.

Vietnam was never far from his mind. Nightmares brought on violent outbursts more than once. There were always sharp, nagging pains in his back and legs and the ever-necessary cane, reminders of his disabling injuries. And the isolation—even back in familiar surroundings where he felt better understood and respected than he had anywhere else—was numbing.

One day, not many months after his return to Gouverneur, Patti read a notice in the local newspaper about a group of Vietnam veterans meeting to discuss counseling needs and mutual concerns. Apprehensive but determined, Cousino and Patti —who, he says, as far as he is concerned has been to Vietnam, too—joined fifteen to twenty others, the first time anyone had ever attempted such a confrontation in this area. Tense though it was, fourteen veterans continued meeting monthly, just to rap: no organization, no officers, no commitments. But talking about these experiences was difficult and took time and effort.

As a boy and young man in school, Cousino had been interested in artwork. He had done sketching and cartooning and had taken special interest in building models, especially cars, airplanes, and military vehicles. His father had often told stories at home about his World War II experiences. Once or twice, as an experiment, Cousino had constructed two or three primitive dioramas, using kits and found materials, based on his father's war stories and his own vivid imagination.

After the first couple of long and try-

ing, but interesting, rap sessions, a friend from the group, Mike McCurdy, who had served in the army's Fourth Infantry Division, visited Cousino at home. He saw the dioramas Cousino had made years before and, together with Patti, McCurdy urged him to try making one of his Vietnam stories in the same fashion. By the third group meeting he had created *Daily Job of a Grunt* (plate 2), showing typical marine combat grunt activities in detail. He now tells the story of it this way:

**It shows a patrol whose mission is to search for and destroy the enemy. Here they have found weapons in a small village. One American was wounded then died of those wounds. They also interrogated the VC [Vietcong] who did it. In this scene you'll also see the enemy, a North Vietnamese soldier, wearing a helmet. I'm in the scene carrying a machine gun with two belts wrapped around my chest (plate 3).**

At the next meeting much discussion transpired—some agreement, some praise, some suggestions for change, some debate over details.

His second and third dioramas followed shortly thereafter. In one, he created a collection of eight different kinds of booby traps encountered daily in Vietnam, putting them all in one piece and calling it *Close Encounters of a Different Kind.* It makes a surreal picture, with its showing of the effects of Agent Orange on vegetation. Clearly it could be a teaching device for the uninitiated, as well as a catalyst for discussion among those who already knew such horrors all too well. His third scene, *Malaysian Gate and Punji Pit* (plate 4), illustrates the primitive practice of grouping bamboo stakes that are razor sharp, covered with feces, urine or poison, and hidden so as to trap an enemy and fatally wound him. This is a gruesome scene of two Americans who have been caught in such traps and have suffered unthinkable pain.

In his first few works, he used scenes as a writer would a rough draft, to instigate further discussions of the subject matter and to evaluate his re-creations. Often he would then refine, even rebuild his scenes, based upon the dialogue at subsequent meetings.

Meant as private expressions of personal memories, the dioramas soon took on new meaning for Cousino when he and others from the group participated in Veterans Day activities in the neighboring small city of Ogdensburg in 1983. Taken along as part of a little display, they provoked much comment from other veterans and especially from nonveterans. The responses of shock and horror and amazement gave Cousino a feeling of being understood and respected that he had never experienced before.

He went home and began to work with a vengeance. In his words, he "had

found a purpose, a way to release [his] anger and pain, and a way to help [himself] and other veterans of that time and place." The early scenes were very simple, even primitive, but the work became increasingly complex and better executed as time went on.

## Cousino as Storyteller

The dioramas seem to fall into three types, based upon Cousino's sources and inspirations. They have been created in no particular order; he still makes examples of all three. The first type depicts common situations; created with some artistic license, these are often composite scenes based upon veterans' general experiences or on stories read or heard secondhand. Cousino describes a number of his favorite scenes of this type:

It was typical at every military base in Vietnam, you always had a checkpoint, the main entrance for going on and off that base. *Checkpoint Charlie at an American Fire Base* [a secured, permanent base of operations] (plate 5) depicts a bunch of grunts, infantry. Their job is to look for weapons, check ID, make sure that the picture that's on the ID resembles the person that was holding it, to stop the Vietnamese from infiltrating onto American bases.

*A Marine's Ass: Mechanical Mule* was totally scratch built from memories and a picture. This piece of equipment was very common to haul ammunition, food and medical supplies from bunker to bunker or firebase to firebase, whatever.

In *Interrogating Some Montagnards* (plate 6), an American is talking to some Montagnards, trying to convince them to work for the Americans, that the Americans will treat them, train them, clothe them and make their living a lot better than what they have. The Montagnards are nomadic farmers and hill people. They move around a lot. They don't like the Vietnamese. They are very backward, primitive people. Mostly when you do see them, they'll be carrying a crossbow or a spear or some other type of crude weapon.

The Vietcong are wearing the red headbands in *VC Recruitment* (plate 7). They go into a village and they'll go to a Papa San, which is the head man of that village equal to our mayor. They would ask him to give them all the young men and young women to fight for North Vietnam. If the chief of that village says "No," what they'll do is take the young boys and young girls prisoners and kill all of the old people, leave American artifacts around, like helmets, weapons, stuff like that, to show that the Americans came in and did it. That would help to increase their propaganda that the Americans are the bad ones, so to speak. This scene shows a typi-

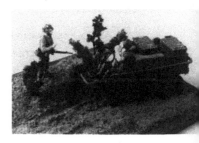

*A Marine's Ass: Mechanical Mule*

cal village, with a Buddhist monk there to help the Papa San negotiate. You can see that they are very, very primitive, backwards, compared to our standard of living, but also that they are very happy.

We call it *Organized Grab Ass* (plate 8). What you're looking at, in a war there's time when you can just kick back at a firebase and these guys here are barbecuing steak, playing volleyball, trying to get rid of some frustrations and the pain of lost buddies, and trying to get organized so they can go on. You need time to relax, write letters home, etcetera.

*Friend or Foe? You Be the Judge* (plate 9) shows that you need sharp eyes to see if this Vietnamese is a friend or an enemy. The black pajamas all look alike and Charlie [one of several American nicknames for the Vietcong] can easily slip by you unless you can tell the difference. A close look beneath the seat of the boat will show the barrel of a rifle stashed away. Watch out!

*Agent Orange* (plate 10) is a story which depicts the jungle foliage—the trees, the grass—no longer there. You see dirt, dead things, brown things that are not supposed to be there. You can see the punji stakes, the Malaysian gate, the skeleton of an American or possibly of the enemy that fell in the trap. Agent Orange was sprayed heavily in Vietnam.

I later found that it was sprayed by the U. S. Marine Corps in every area that I served.

The second type of scene is based upon his own personal experiences and captures with incredible detail his vivid memories. The stories which he had stored for so long began to come out in the rap sessions with a very few trusted veteran friends, in professional stress counseling sessions, and in these miniature moments which are much larger than life to Cousino. He tells about some of them: *My Hootch at Red Beach or An FNG's First Impressions of Nam* (plate 11) is what I first saw of Vietnam. This scene depicts me with a seabag and pack on the boardwalk in front of my "hootch," the Vietnamese word for small house. In the countryside, the hootches were very primitive structures, made of bamboo or like that, but we called these American military structures hootches anyway. The other guy on the boardwalk is hollering "F-N-G!" He's saying "Your FNG is Here!" And I didn't understand what FNG meant. I soon learned: Fucking New Guy. Or we called them "Cherries," meaning brand new guy in Vietnam. So this was my first impression of life in-country. It looks very peaceful. In fact, I still have a picture of myself by a hootch in Khe Sahn in 68 which I sent home to my family.

It was very common for FNG's—like me

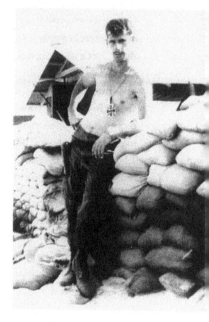

Michael Cousino at American base in Khe Sahn, 1968. Unidentified photographer.

in this scene—to be assigned working parties for the first thirty days, such as mess duty, latrine duty, or like this one, which I call *Burning Shit in Vietnam*. This is where we took five gallons of gasoline and diesel fuel and we mixed it together to get rid of human feces. This is a hard and unpleasant job. Even after several showers, you could not get rid of the stench.

*Zapper* (plate 12) shows part of the duty we pulled outside our hootch when we first got to Nam. This scene shows me, sitting down with a canteen cup, smoking a cigarette, and we're on "perimeter duty." We're supposed to be looking out at the wire which was very common around every bunker. Charlie would sneak in at night. Here one VC is trying to sneak in under our wire and he's carrying a satchel charge of explosives (plate 13). He wants to blow up the bunker and blow a hole in our perimeter.

Parts of Vietnam are very, very beautiful. An awful lot of places in North Vietnam and I Corps, where I was at, reminded me of home in St. Lawrence County. *No Time to Stop to Pick the Flowers* (plate 14) depicts me on the tank as a hitchhiker. We just got tired of walking, a tank came by and we thumbed a ride. Because of how the landscape is up here in St. Lawrence County, all you have to add is a few palm trees. Some of our fields look like rice paddies and parts of Vietnam

have the mountains, some hills, just like we do here.

*Camping Out in No Man's Land* (plate 15) depicts me after I found a puddle, basically a hole from a bomb dropped from a B-52, creating a crater. It had water in it so I set up a little lean-to, just like camping out here in the North Country, soaking my feet and writing a letter home. We got free time, but every time you got some time, you utilized it to the max. And you never let your guard down! Once you dropped your guard, Charlie would get you!

In a combat situation, when a marine gets hit, we would holler, "Corpsman [medic] up!" and a corpsman would pop up. Nine out of ten times he would get shot. So, if a marine got hit or wounded, the other marines would go out and get him and bring him back. This scene depicts me being carried by buddies in February 1969. That's why I call it *Marines Take Care of Their Own*.

*Being Run On: My Nightmare* (plate 16) is one of the hardest scenes I ever did. A common fear for grunts was being run on, being surrounded, with no place to go. The old saying was, "If Charlie comes at me, we'll go out the back, Jack," but sometimes you couldn't because Charlie was there. Then you're calling for a medevac [medical evacuation, usually

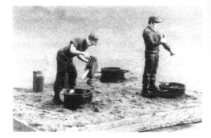

*Burning Shit in Vietnam*

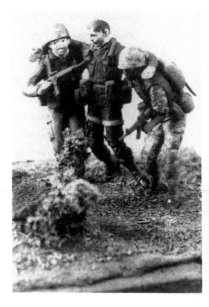

Self-portrait of Michael Cousino being carried from battlefield by buddies in *Marines Take Care of Their Own*

**14**

with a helicopter] to get you out of there. This scene shows the bad part of my nightmare, 'cause I woke up pale, sweat comin' down. My wife couldn't figure out what was wrong with me. All I said was, "Goin' out the back, Jack!" and she didn't know what I was talking about, until I showed her, when I got done with the scene, what my nightmare was all about.

*Christmas in Vietnam, 1968* (plate 17) depicts me when we were out setting up and I heard this noise and a six-barreled tank came through the boonies and turned out to be a **Marine Corps Ontos**, which is a Greek word meaning six-armed, like an octopus. These guys were coming through and, since it was Christmas, they threw me a pack of cigarettes. In any of my stories that you look at, if you see a pack of Marlboro cigarettes either on a helmet or close by, it depicts me.

*Our First Meeting: Folk Artist and Folklorist* (plate 18) depicts the first time that Varick Chittenden came to my house to see my artwork. I guess when we first met, we didn't know where this would go. He called me a "folk artist" or "storyteller." I just called myself a "diorama builder." Eight years later we are still doing shows, etc. Varick is a friend who has made a difference in my life, my family's lives, and veterans.

A few of the personal stories Cousino has been slow to show or talk about. He finds it necessary at times to go into his tiny den/bedroom, which has been converted into workspace and storage, and just sit there with these scenes, working things out. He will be there hours at a time (once as long as three days) thinking, creating, exploding, listening to music, wearing combat gear, whatever—and then go on with life as usual.

The third type of scene, shared veterans' experiences, is generated by the hours and hours of sessions that have become so important to Cousino and several of his friends in the last few years. The situation for telling stories varies greatly. Cousino says: "It doesn't have to be in group therapy. It can be anywhere basically, anywhere you get two vets together. It might be here at home, it might be at the office, at a rap group. It might be at a parade, or a social gathering. But Vietnam always seems to come up."

Cousino tells little about the details of people's reactions when they see his artwork, but another one of the local veterans, Nellie Coakley, says that "there is often just silence at first viewing, absolute silence. Then two or three people off to the side are speaking softly. Some may joke, some may cry. Once or twice a newcomer has walked out, never to return. It was more than he could take."

For the most intimate of his friends,

Cousino has created specific and detailed scenes of experiences that they have described to him. Conversations with them move him visibly, and he feels that it is an act of friendship—being a real buddy—to build for them the stories that they've been willing to share with him. These pieces are made as gifts and are never sold. In several cases, Cousino is simply unwilling to share any of the details about the soldier's story except the most obvious. To divulge a name, except when he knows it's agreeable to his friend, would be an act of betrayal, an absolute taboo for men of combat. Some examples he will talk about:

*The Set Up* (plate 19) is a story told by Bart, an army vet from one of the armored divisions in Vietnam. They're setting up camp, getting ready for the night, 'cause every guy and gal that served there knew that nighttime was Charlie time. When you stop, somebody is always on duty, looking, listening for the unusual. Everything they need to camp out is carried on that tank.

Mac is an army vet whose story started out as a joke. I came up with a bunker [a secured area, often temporary, built of sandbags], put twin arches and a McDonald's sign on it, and called it *Mac-donald's in the Field* (plate 20). Mac is sitting on the side on guard duty. The situation is real but it is a joke. It made the vet happy.

Skip's story depicts a Navy Seabee (U.S. Navy Construction Battalion) up in Dang Ha, with Skip on a scratch built bulldozer, pushing the foliage back so they have a free-fire zone, an open area, so they can actually sit there and shoot the enemy. I call it *We Can Build and We Can Fight* (plate 21), a World War II motto for the Seabees when they were formed. This is in honor of the navy veterans of Vietnam.

The job of a *Forward Observer* (plate 22) is to go out to spot the enemy, eyeball the area, and call the information back. We called it "snoop and poop." It may be one guy or sometimes a four-man K[ill] team. They will be either dressed as VC in black pajamas and straw hat or in camouflage. Here Dave, a captain in the Eighty-second Airborne, army, is out there in the grass, snuck up on Charlie, and is just reconnoitering, looking at the situation. His orders were "not to be seen, not to do any action, just go out there and look and report back." This is a lonely job because you're a guinea pig. It takes a lot of grapes to do it.

*Snoops and Poops* (plate 23) shows a recon marine unit with a dog handler (plate 24), a story told by Slack. In Vietnam in '68 this was common. The dog was used for a variety of purposes—to find booby traps, find Charlie. It was an elite group of men who think as one. They know exactly what each man can do. Sometimes you

**16**

don't need any verbal communication, just look at 'em, a sign, a gesture. He knows exactly what to do.

*Up on Step, PBR* [Patrol Boat River] (plate 25) is one of the toughest stories that I had to do because the boat is completely scratch built. The whole scene is scratch built. No models or kits of river patrol boats were being made at the time. It is made of fiberglass, carries .50 caliber guns out front, one 7.62 M-60 machine gun in front, and two M-60s, one on the right side, one on the left side. The vet telling the story, my buddy Bill, is the last person in the boat, on the .50 caliber machine gun. A VC is in the tree line and has an RPG [rocket-propelled grenade], which will shoot at that boat. It would blow that boat all to pieces. I wanted to show how thick the jungle was and how dirty the water was over there. That's why they were called the Brown Water Navy or River Rats. The men on these boats' missions are slightly different from the average Vietnam vet who was a grunt. One mission was to search out junks—a small boat or sampan which Vietnamese people use for transportation and live on—and they're checking for ID cards, weapons, VC guerillas, things like that. The VC would smuggle in a lot of arms and weapons by this means, on these small boats, and they would do a very good job of camouflage. This scene I

consider to be my masterpiece till now. I am proud to dedicate it to my good buddy Bill, member of USN River Division 512 in Vietnam.

The Seals are one of the Navy's elite units which two vets I've met belonged to. In *Seal Team Ambush* (plate 26) Charlie has showed himself, fired upon the point man to make the other Seals chase him, but in this case they're trying to get back one of their wounded men to a pickup point. After I completed this scene, both Mike, an E-4, and Don, an officer, an ensign, told me I got this right.

In *Low Level Hell* (plate 27) a two-man chopper [helicopter] crew is flying just at the treetops or even lower, looking for mines in the road, VC guerillas, whatever, like convoy duty. Mike, an army vet who told me this story, was a crew chief and door gunner, out on reconnaissance missions, flying over the sector without landing. "Low level hell" meant "to draw fire." Here Charlie is in the grass, but the chopper is so close, they can see each other's names on their helmets.

There is a fire team of four marines in *Caught in the Open* (plate 28). This is a machine gun fire team, when the assistant gunner got hit in the head. He made it back, but they're walking through the open dry rice paddy, saying, "Where the hell is that medevac?" And they're tryin'

**17**

to get their buddy out of there (plate 29). This was told to me by a friend, a jarhead [a marine].

*What the Dark Hides: The Morning After* (plate 30) is a story my DVOP [Disabled Veterans Outreach Programs] colleague Don told me about his worst memory of Nam. In this scene, the army grunt has been ordered to stay in a dugout in the area overnight, where he has his M-60, his radio, and his .45. If he hears any noises or suspects any movements, he has been told to set off the claymores with the hand device. A claymore is a mine, made up of one hundred ball bearings each and he had about ten of them set to fire in all directions. In the middle of the night, he heard a noise and touched them off. Here, at first light of dawn, he finds to his amazement that several women and children have been brutally killed. Even though we have known each other at work for eight years, he didn't discover that I was doing my artwork until he went with his family to Vermont to visit the Moving Wall and saw a notice for an art show about Vietnam at the museum nearby. When he went in he saw "Mike Cousino: Folk Artist." "That son of a bitch!" he said. "I didn't know he did these things." Shortly after, he told me this story and I worked for a long time on this scene. He says my art work "heals like the Wall."

*Medevac: Getting a Free Ride* (plate 31) is the story of Frank, a marine from the Third Marine Division, who told it to me at the Buffalo art show. It depicts four marines going out on No Man's Land, where there's no place to hide a chopper to pick up a wounded marine. In this case, Frank started bitchin' and hollering, "I'm wearing that damn flak jacket [armored vest worn to stop shrapnel] and they got me in the legs!"

*Death Comes to Us All* (plate 32) is a story shared by Willie, an army grunt, showing two guys from graves registration, which in my opinion was the worst job to have. This shows an army personnel carrier which was hit with an RPG round in the front, which killed everybody inside. That was one good reason why we'd ride on the outside because you could shoot right through it. In the scene, Willie is waving good-bye to some guys he knew.

*Auto Shop, USA[rmy]* (plate 33) is Greg's story from Vietnam, yet it could have been at any military installation. You don't see any combat here, it's peaceful, he's a mechanic (plate 34), OK? No matter what job a veteran had in Vietnam, he did his job 110 percent. They worked all day—might have been a supply clerk, office clerk, truck driver, whatever—but at night they would pull perimeter duty. They would have to stand watch. You didn't get that much sleep in Vietnam.

*The Country Store* (plate 35) shows a typical primitive structure in the country· which is a little store where they'd sell you cigarettes or Ba Muoi Ba 33, a Vietnamese beer, which we'd call "tiger piss." They'd also sell you cold sodas and a variety of other items. I wanted to show the size of our vehicles in relation to their structures which were very small. You could run 'em over real good. This scene depicts a story told by Fred, from a marine armored division.

*The Hooker or Numba' One, Boom, Boom!* (plate 36) shows a common Vietnamese prostitute. You could get laid for a pack of cigarettes, especially if they were menthol—Salems, Kools, etc. In this story, told by Ted, you can get laid for two bucks. That's two Vietnamese dollars, not Yankee dollars! This depicts a small, country girl, carrying a basket with her bicycle, just passing through, and stopped to make a deal with these army personnel. One guy would take her into the bunker, then another guy, then another. She gets her money and she's on her merry old way down the road again.

*Don't Forget Us, the POWs* (plate 37) is a very special scene, because I made it after I received an anonymous phone call at home after some of my stuff was shown on a local television program, shortly after I got started. Some vet in our area called me to say I was not talking about POWs or MIAs and went on for an hour and a half to describe some of his experiences. Being a prisoner of war is no picnic. You're tortured daily, you're beaten daily. They drag you through a village, from village to village, and try to break your morale, try to go against what you believe in, try to show you that you are wrong, killing kids and women, things like that. As the survivors of a Viet Cong ambush, these two men were subjected to inhuman treatment. They were beaten, stripped naked, and paraded through the streets of North Vietnam. The idea was to strip the soldier of his morale, leaving him with guilt. This treatment either strengthened him or broke him. Vets experience great psychological anguish when attempting to describe such experiences because we feel deeply for each other.

Since this one I have made several others which depict POWs in other ways, including *In the Pit, Walking to Hell,* and *Twenty Years Later and We're Not Home Yet! Why?* (plate 38). For this one, I used my imagination to show that a vet, captured in 1965, would look like this now. Let's bring them home, now, America! They are still serving in Vietnam. I dedicate all of these to the POWs and MIAs and their families. I don't know if that guy has ever seen any of these scenes. I may never know.

Mike is my best friend, a guy who I met in

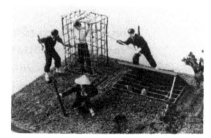

*In the Pit*

**19**

our very first group meeting and discovered that our squad had saved his butt after his chopper had been shot down back in I Corps twenty years before. We recognized each other and have been tight ever since. This scene represents *The Promise* that we would always be there for each other. When he realized that I was beginning to go downhill, Mike promised me that he will always keep physically and mentally fit, in case anything ever happens to me or Patti or the kids.

Tom came back from Vietnam and went to Providence, Rhode Island, where he had gone to college. He had lost his left leg in Vietnam and this scene depicts him talking to young kids in the street. The black kid asked him, *"Why Did You Go to War, Man?"* (plate 39). Tom answered, "I either had to go to war or go to jail." The kid then said that if he was called, "Hell, I'm going to jail!"

This scene depicts *Nellie, Our Group Counselor* (plate 40) in her office, where she counsels Vietnam vets about PTSD [post-traumatic stress disorder] and other things. She was a MASH army nurse herself in Vietnam. This shows her office, where she tries to help us get our lives back in some kind of order so we can forget the past and go on and live as Americans and stop just existing. This scene took me at

least six months to build because everything in it is scratch built.

One scene, which he calls *Taking Out a Sentry*, was one of the first that I saw in his collection. When I first met him, he attributed the story to an "unnamed friend," who had told him about the incident in confidence. Only recently has Cousino declared that the story is indeed his own experience and that he is now able to talk about it, a situation that may be repeated as he continues his own emotional healing. In 1986, he described it this way: *Taking Out a Sentry* (plate 41) shows a buddy of mine who has told me about the time when he encountered two VC. What they're doing is, you got one guy on guard for the other guy who is setting a booby trap. This one is a Malaysian gate, which will swing to impale punji stakes into the chest or lower abdomen of anybody that's walking down that trail. Nine out of ten times it will be an American. Sometimes the VC will get caught in their own trap. At any rate, the American has to think fast and do what he has to do. The knife to the throat worked (plate 42). This is the kind of memory lots of guys don't want to talk about.

## Cousino as Folk Artist

Cousino's work is an interesting example of folk expression, as clearly a form of narrative as are war stories and

*The Promise*

ballads. It is also folk art. Like the work of memory painters who have been recognized for re-creating scenes of daily life on the farm or in city neighborhoods decades after they had personally experienced them, these dioramas encapsulate and distill moments of community experiences. And many are products of the group interactive process, clearly expressing the values and aesthetics of soldiers who still have trouble putting their own memories into words. Cousino, like other folk artists, has emerged as the visual spokesman for his community, this one of "grunts." Jane Beck, director of the Vermont Folklife Center, which hosted Cousino's touring exhibition, terms such artists "local laureates" in their own group (1982: 25).

As informal art objects, Cousino's miniature dioramas are personal inventions, idiosyncratic works that are unique and individual expressions. Their function—as historical documents and teaching tools—lies in their narrative content. Much of what is generally called folk art has a story attached to its creation and original use. Beck adds that such narrative art forms "reflect a traditional lifestyle and a shared community experience which is at the same time a personal expression within a traditional mode" (1982: 29). Cousino's scenes serve exactly the same role as narrative paintings (or snapshots or home movies) for his community of veterans.

As Cousino continues with his work,

he increasingly sees himself as creating a history—or at least a story—of the war in common grunt's terms. Almost all of his scenes are single episodes, but he has developed plans for several series of scenes, color coded even, to illustrate sequences of events that the "frozen moment" of one scene, like one still photograph, doesn't do for him. Art historian Elizabeth Kahn describes Cousino's scenes: "His so caringly-put-together views of combat in Vietnam belong more to the realm of oral history—telling it like he saw it, in the language of the time, without a sense of creating any kind of monument for the future" (1987).

According to folklorist Beck, Cousino's scene/stories, like other contemporary narrative folk art, are "not so much the traditional folktales [of traditional storytellers] of bygone years, but snatches of autobiography, vignettes of important personal events" that are as carefully shaped and well constructed as their verbal counterparts (1982: 41).

While the word "artist" is not one that Cousino would have used to describe himself when he began to make scenes, in the short time that he has been working, he has gained local acclaim from his vet friends and from the general community. The local newspaper stories, television appearances, and exhibitions have validated for him his role as artist. Like other folk artists in other groups, he is seen as a master of

certain requisite traditional craftsman-like skills; yet he is also among the few to develop a flair for expression, a good eye, and sense of creativity that does not exceed the specific limits of group taste.

Modeling and diorama building are now so popular that at least two or three well-financed monthly magazines on military modeling alone have become widely available. Most hobbyists seem to prefer following printed instructions to reconstruct in exact detail scenes from heroic battles in history, from the Peloponnesian War to the Battle of the Bulge. When Cousino began to build his scenes, one of his first discoveries was that no major producer of kits was offering any of the vehicles, equipment, or soldiers of the Vietnam era. Perhaps the demand was not yet sufficient; perhaps the war was just too controversial.

In almost all his pieces now, Cousino uses readily available 1:35 scale models and figures as the basis for creating everything else in his scenes. The one-inch-to-thirty-five-inch relationship means that an average American male would be about two inches tall in the models. That size allows him to create some of the other tiny details of the scene in proportion. But he also purchases some kits with slightly bigger or smaller scales to accomplish certain relationships.

On the front of his work desk is a cabinet—"Mike's Morgue" or his "body shop," he jokingly calls it—full of separated tiny pieces from kits he has purchased at hobby shops. Tiny drawers are marked for such items as left arms, right arms, lower extremities, torsos, helmets, gear, and rifles (one for American, another for Vietcong). In addition, he has "junk boxes" with an incredible array of scrap materials that he has already used or is keeping for future use.

When he describes how he accomplished some of his early work, he seems almost as enamored of the ingenuity and innovative techniques required to achieve realistic results as he is with the stories he was telling. Building World War II army jeeps and painting and modifying them to resemble Vietnam-era versions was a start; building a helicopter or a tank, then melting it down in the oven or torching it with a butane cigarette lighter was a common practice. Using World War II GIs and modifying headgear or gunbelts into arine issue equipment of the next generation was easy compared to making over Nazi infantrymen—the only ones he would use—into Vietcong Charlies with black pajamas and red headbands.

Folk artists working in many different kinds of media have often used found objects to help them re-create the appropriate textures, forms, and colors in their work. For Cousino, who has so many special images to build, being creative and resourceful is both a necessity and a pleasant challenge. Dried moss from hunting

trips in the woods becomes foliage; a bar of soap is shaped into a water buffalo; soil is mixed with household glue or paint to create the terrain of the bases of most scenes; the plastic mesh from a bag of onions is fashioned into a volleyball net or strings of barbed wire. A *Playboy* centerfold is reduced in size over and over again on a color photocopier until it is smaller than a thumbnail. And he jokes that Patti is always complaining about his stealing straws from her broom whenever he is working on a bamboo hootch.

Of all the work that Cousino has done, he is most proud of scenes, or elements of scenes, that are entirely of his own making, "scratch built," in his words. In order to achieve the realism of his internalized images, he has had to build many different things, from Vietnamese huts to C-ration crates (canned meals for use by combat troops in the field) to banks of sandbags around firebases. In many instances nothing even similar in scale or texture is available in the market, so he has developed techniques of his own. He has delayed the construction of a number of scenes until he has been able to work out satisfactory methods.

Only recently has he been able to re-create muddy water, an ever-present condition in Vietnam. He has discovered that layers and layers of polyurethane varnish, poured carefully over damp sandy clay for a period of many days, will produce the right color, as well as the effect of moving current. A great personal challenge has been to produce original models of certain military vehicles, like the navy patrol boat for his friend Bill's story.

Cousino has developed a process for creating that varies slightly with each piece. "Ninety per cent of the work is thought," he says, "planning, sketching, reading books, getting the details." For the stories of other veterans, he accumulates notes from numerous direct conversations, phone calls, and letters. He has also put together a significant library of books on the period (Patti has given him the *Time-Life* series on Vietnam, and he has found Sears catalogs from that time, for instance), documentary and feature films, and personal and loaned photographs. Each time he is planning a scene, he consults some or all of these sources for details.

Before he starts to build anything, he thinks through the entire piece in order to make it "real":

**I can see it in my mind, what it's going to be, before I make it, while I'm making it, and after it is complete. It amazes me at times, 'cause I go back in my memory and actually visualize the scenes. Even when a vet is telling me, I'm listening but I'm storing it up at the same damn time and then I might say, "Yeah, I can do that!" Then I'll make notes and I'll put it aside. Then when it gets time for me to build that scene, I have to get back in the**

mood, "get the jazz." The hardest part is actually getting psyched up to do it. While I'm doing it, if I run into problems making some part of it, I'll stop that scene until I get that problem squared away. It might be six months or a year before I go back to it.

As an illustration of the way Cousino goes about creating a typical scene, I have chosen *Joy Ride*, a personal story that he says depicts him when he "borrowed" a motorcycle and was running down a trail. As he approached a small pond, he suddenly came upon a footbridge with a friendly village woman—"Mama San"—on it. "We barely missed each other," he says. "It was one of the humorous times I had in Vietnam. We all try to remember those."

After deciding what he wanted it to look like and how to create the major parts, he began with building the motorcycle, a World War II era BMW model, but left the windshield off to make it just like the one in his memory. For the figure of himself (plate 43), he began with the legs and lower torso and added jungle pants pockets made of Pla-Doh. With his X-Acto knife, he shaped the clay into the large, slashed pockets. He then chose arms to fit the bike and selected a "boonie hat" (soft, narrow brimmed hat worn as part of jungle fatigue uniforms). To get the effect of the rolled brim he took a 1:32 helmet,

heated its edges with a candle, and carefully used a sewing needle to roll the brim up in the air, and then fit it around the head. The figure and "bike" were then complete, except for the paint, and he set them aside.

Since the setting was such an important part of the story, he then concentrated on the base, for which he chose a thin piece of plywood cut to nine by seven inches. He mixed the usual combination of dirt and housepaint and, while it was still damp, molded the horseshoe-shaped pond as it appeared in his memory of the incident. "Then I went outside for old twigs to cut up for the bridge," he says. With Super Glue he fastened all four upright posts of the bridge to the base and soon after the crosspieces to the posts. While the dirt mixture was still wet, he sprinkled the grass (purchased from the hobby shop) on it so it would stick. When the dirt was dry, he painted the horseshoe with brown paint, and when that dried, he added two layers of polyurethane to get the effect of water.

Nonmilitary figures are usually the most difficult for Cousino to create, and the Vietnamese woman and child in this scene (plate 44) were no exception. After searches through all of his materials, he found the figure of a male World War II German soldier that was the right size. The baby, on a (much smaller) 1:72 scale, is a Russian soldier with a helmet! In the scene, the woman holds a water pot, made of a short piece of rubber tubing, with a

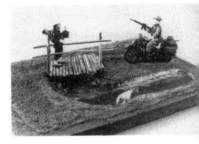

*Joy Ride*

spot of glue for the bottom, and the handle is made of black thread. The baby is wrapped in painted toilet paper "for the blanket which the women tied their kids to their backs with." Cousino jokes, "Toilet paper is my best medium. I use glue or paint it into all kinds of things." He then cut away the boots from the original figure and fashioned sandals with paint. For the tunic—"pajama tops"—he carved plastic from the torso, added breasts with spots of glue, and shaped the hat of brown paper from a shopping bag.

In the final steps, he painted whatever details he'd not yet added, including the startled expressions on the two adult faces. A drop of glue made the headlight for the motorcycle, and a pair of ducks were among the additions. "I had to buy a whole kit of animals just to get those damn ducks," he says.

*Joy Ride* is his own experience, but if he were creating another veteran's story, at this point he would take the scene to the veteran for his or her approval. "I show it to the vet only when the scene is complete," he insists. "Only Patti gets to critique a piece along the way." If the vet is not satisfied, or if some details are not right, Cousino may redo it.

Several writers on material culture, such as Susan Stewart, Barbara Kirshenblatt-Gimblett, and Hufford, Hunt, and Zeitlin, have observed psychological reasons for a person's working with miniaturization,

some of which accurately describe Cousino. These include the ability of the miniaturist to gain control over his subject matter, to direct his audience's attention to specific details within the context of a larger setting, and to use such exact details to tell the truth about his subject.

Since Cousino began making the pieces during the early period of counselling with the stated intention of using them to express himself, the work has allowed him to sort out his emotions about Vietnam in a way that other efforts had failed to do. Kirshenblatt-Gimblett suggests: "Like the collectible, the miniature tableau offers the pleasures of a hermetic universe, autonomous and controllable, where connoisseurship is a quest for the perfect fit"(1987). And, about Cousino, Kahn states that "perhaps the self-contained quality of his work could stand visually and mentally for his need to control and his past sense of confinement"(1987). While many veterans of Vietnam have suffered through physical and psychological traumas equal to his own, unlike some of them Cousino seems finally to have gotten his life back together since he started feeling the success of his artwork. Being able to tell whole stories as he holds the small scenes in one hand and points to details with the other is very satisfying for him.

Cousino repeatedly says that, despite the fact that he is often re-creating specific

stories about himself or his friends, he wants every combat veteran who sees them to appreciate and understand just what he is doing. Ernie Amabile was able to watch hundreds of visitors—many of them Vietnam veterans, of course—as they filed by Cousino's scenes on exhibition at the New York State Vietnam Memorial gallery. He describes some reactions: "Many vets will smile and shake their heads when they encounter a scene that has an unexpectedly 'right' touch: the *Playboy* pictures in the outhouse, the package of Marlboros on the steel pot, the ubiquitous graffiti (mostly peace slogans or antimilitary pronouncements) on the walls and on tracked vehicles. Some vets shudder when they recall their own firefights or ambushes, then leave the gallery having undergone a complete catharsis."

Because of their small scale and because kits for modeling cars, airplanes, or tanks are often found among the toys in department or discount stores, miniatures are often perceived as children's playthings. But adult miniatures and children's toys are usually created for different reasons. Nellie Coakley observed that, when men who had served in Vietnam first saw Cousino's work, "[t]hese were *not* trivial, child-like toys or models anymore. They were powerful reminders that have affected some of the men deeply"(1986).

For most people who see miniatures, especially for the first time, it is the incred- ible detail used by the artist for every part of the diorama that impresses the most. In their characterization of the memory art of older people, Hufford, Hunt, and Zeitlin, coauthors of *The Grand Generation,* suggest: "There is a passion for detail that distinguishes adult miniatures from childhood toys. The [adult] miniaturist and his peers are connoisseurs of such detail. In the face of a growing inability to affect the physical world on a grand scale, they attend closely and authoritatively to the world on a reduced scale" (1987: 61). Elizabeth Kahn's reaction to the detail in Cousino's work is typical of dozens of comments overheard in the gallery: "My God, what incredible patience, deftness of fingers, concentration to produce an image that took seconds to experience, but days and days to remake!"(1987) Mike McCurdy, Cousino's closest friend and fellow Vietnam veteran, has watched him develop and describes him as "an artist because he goes for the truth, for something real"(1987), an observation substantiated by Beck when she states that "specificity is a part of every good narrative, bringing 'truth' and 'reality' to its subject" (1988: 40).

"For the vet viewer, no instruction is needed; it had happened before, to them— the ambush, the base camp, etc. In this sense, Cousino's work does express the collective experience, but only one that can be passed on by the 'family members' of that community" states Elizabeth Kahn

(1987). Their powerful reactions to these tiny representations of real situations indicate a strong group aesthetic. It may seldom be verbalized, but it is real, and it must be acknowledged.

As Barre Toelken has said of other folk artists, Cousino is "fiercely aware of what is good and beautiful in [his] area of expression, and even more aware of what the close group will think about it" (1979: 185). Cousino told me recently:

**First of all, I have to be in a damned good mood. And then there's no way I can screw it up. It may be bragging, but I've made some stuff like cameras, cigarettes, Coke cans, pipes, mess kits, stuff they don't make (in miniature) on the market. After I get in this mood, I can't mess it up. I'll try it. And it turns out very well. I'm pleased with it. All right, then, the vet looks at it and says: "Damn it, look at that! Oh, you even made a little canteen cup. You know, it's all there." It's personal. They put it on their mantel and it's theirs.**

He knows—and they know—that it's their art.

Despite the great number of pieces created and the considerable exposure they are now getting, Cousino has never sold a single scene. He has occasionally been approached and asked to sell an existing piece or to accept a commission for a new one. He always refuses and almost seems troubled about being asked to sell them to someone he doesn't know. Beck has observed that most folk artists, especially early in their careers while their reputation remains only local, usually make things only for their own pleasure or to give to family members or friends as gifts, even as heirlooms. She states: "The person for whom it is made shares the story of the piece. . . . The folk artist's immediate community knows the stories of the artist's creation, but beyond this, an emotional bond exists between the artist and the individual for whom the work is created. Frequently the piece is considered to be so special, so precious, that the owner will not part with it for anything" (1982: 42).

A typical reaction by local veterans who have been given scenes by Cousino is Mike McCurdy's: "I treasure them as sculpture and because he gave them to me, though Mike's a giver and not a taker. When he gives them to you, that's special to him, a personal tribute to friendship"(1987).

In his catalogue of the 1977 exhibition of selections from the distinguished Winterthur collection, Kenneth Ames assailed several myths about folk art. One of those myths has been the image of a conflict-free past, where what we have seen has minimized the role of social and economic conflict and conveyed the sense of a safe and serene life. He adds: "Little has been collected or exhibited that is 'vicious, hideous, or obscene' " (1977: 44).

Eugene Metcalf, a social historian and folk art critic, has observed that folk art and its makers quite often deal with serious, even negative, subjects: "Although, as collectors are fond of saying, folk art is indeed a kind of American symbol, it represents not only the bright hopes, but also the dark realities which we as a society have sought to avoid. For folk art symbolizes both the hoped-for triumphs of American democracy, as well as the reality of failure, and in addition to representing our vision of an idealized American past, it is testimony of the irrevocable loss of that past, and to the dislocations and tensions of our modern present" (1986: 35-A).

This is precisely what Cousino's scenes are about. His is a personal mission: first, to clarify his own experiences and share them with other grieving vet friends; second, to provide a record of what he knows happened, in order to gain the respect of those who were not there and promote reconciliation; and third, to show the unbelievable atrocities of this war in realistic and frightening detail. What we see is what they got!

Cousino's collective work reminds me of Ralph Ellison's definition of the blues and how it became the folk art form used by many blacks in shaping attitudes toward their lives while growing up in traditional black families. He said: "The blues is an impulse to keep the painful details and episodes of a brutal experience alive in one's aching consciousness, to finger its jagged grain, and to transcend it, not by the consolation of philosophy but by squeezing from it a near-tragic, near-comic lyricism. As a form, the blues is an autobiographical chronicle of a personal catastrophe expressed lyrically" (1964: 77-78).

Like American blacks, numerous other groups, such as combat veterans of Vietnam, have been denied equal status in this country and have often been badly treated or ignored by our institutions of law and culture. Alienation, frustration, and rage have been central in their lives and in the creative expressions of their artists.

There are also parallels between the narrative dioramas Cousino creates and the narrative paintings of some other twentieth-century American folk artists. Celebrated artists such as Grandma Moses, Queena Stovall, Harry Lieberman, and Clementine Hunter began to produce late in their lives, using memories of their distant past to make personal records that also became community artifacts.

Recent studies of folk art among the elderly have advanced the theory that certain personal traumas—loss of spouse, poor health, or the suddenly expanded time resulting from retirement—have been turned by some into positive outpourings of artistic expression. On the subject of memory and memory painters, Didi Barrett, curator of an exhibition of folk art by the elderly at the Museum of American

Folk Art, wrote that "for some, art becomes a form of expression at a time when they feel no one listens to them any longer" (1985: 5). Though their peers in similar circumstances might be depressed or lonely, such people have found that their artwork becomes a means by which they can participate in local life again, both by recalling memories of previous experiences and by sharing those memories with a community which, at some point, often seeks them out.

Gerontologist Robert N. Butler has described the importance of memory—and of sharing memories with others—among the elderly, when he defined life review as "a naturally occurring universal mental process characterized by the progressive return to consciousness of past experience, and particularly the resurgence of unresolved conflicts" (1969: 266). It happens at a time when one thinks of getting his or her life in order and of moving on. Many older people, if given the opportunity, would assume the role of community storyteller or of an elder, the kind of position that some cultures in our world treat with the greatest respect. Their memories and their chance to set the record straight are what they see as their greatest contribution to the next generation.

Unlike Grandma Moses and her generation of folk artists, Cousino does not idealize or romanticize his experiences. The horrors, frustrations, and confusions of the combat soldier—and of the struggle to be recognized and accepted for years afterward—are clear to everyone who sees his work. Despite their diminutive size, his scenes shout and scream their horrible contents.

Beginning with the counselling and the rap sessions, on through getting a degree and a job, Cousino has made order out of chaos and brought positive new direction to his life. The changed environment for Vietnam veterans—the Wall, the many motion pictures (good and bad), and a variety of television documentaries and dramatizations—have, at last, made it more acceptable to have been an American combat soldier in that time. But for Cousino the dioramas that he has used to re-create some very private experiences and nightmares may have been the best therapy of all. "Each stage of life is a kind of world that envelops in the present, but which in retrospect lives only within us," the authors of *The Grand Generation* conclude. Appropriately here, they add, "In miniatures we can exteriorize the interior world of the past, making it possible to share more fully with witnesses" (1987: 60).

Though Cousino is only forty-eight, hardly half the age of some of the elderly artists who have been studied, he, too, wants to set the record straight, to teach his own and other children about a war that nobody liked and about the reasons he and his veteran friends did what they

did. His art has helped to resolve some of his own conflicts, putting an end to that lifetime already lived and allowing him to get on with a new life.

Concerning his present status, Cousino gives a great deal of credit to his art. Men and women have told him—or sometimes he hears it secondhand—that his scenes have really helped them with their own lives. He says:

**So that makes me feel good. I say, well, wait a minute! These aren't just my scenes. I'm doing something for my personal "out," but I'm also helping someone else "out." And it works. What more can I ask?**

## Cousino as Spokesman

Until recently, Cousino's scenes had not been viewed by many people. A major point in his life as an artist was the invitation in late 1984 from the Owen D. Young Library at St. Lawrence University in Canton (twenty-five miles from his home), to exhibit eighteen of his works for a few weeks. Being shown was important to him, but for a Vietnam veteran to be recognized on a college campus, even fifteen years after his wartime experience, was symbolic and redeeming. In gratitude, he gave the library six of his earliest pieces for their permanent collection. During the following two years, several local public libraries and veterans organizations in northern New York sponsored small displays of his most recent creations.

In the winter of 1987, Cousino was one of a number of featured artists to exhibit and discuss their work at a spring festival at St. Lawrence. Devoted entirely to arts of the Vietnam period, *Art and the Vietnam Era: The Politics of Memory* was an impressive program of lectures, art exhibitions, film viewings, dance and music concerts, poetry readings, and more. During that time, he met Ernie Amabile, himself a Vietnam veteran and then director of the New York State Vietnam Memorial in Albany. Amabile invited Cousino to have a one-man exhibition at the gallery in the Memorial during the summer of that year. Nearly sixty pieces were selected for the exhibition, accompanied by a small catalogue and an interpretive essay that I wrote. The show coincidentally opened on Cousino's fortieth birthday, a day he now says he'll never forget. A large, enthusiastic crowd came to the reception. Amabile has since declared attendance at the six-week installation to be by far the largest for any artist in the gallery's fifteen-year history.

As a result of that success, Traditional Arts in Upstate New York [TAUNY], a folk arts organization in Cousino's home area, decided to sponsor a grant proposal to the Folk Arts Program of the New York State Council on the Arts to subsidize the fabrication and transportation costs for a one-man show of his dioramas. The result

was an immensely successful exhibition of seventy-five pieces called *Private Expressions/Shared Memories,* which toured for nearly two years. The original site was the Roberson Center for the Arts and Sciences in Binghamton; installations followed at the State University College at Buffalo, the Arts Council for Wyoming County in Perry, New York, and the State University of New York College of Technology at Canton. Hundreds of people came to each exhibition, including dozens of Vietnam veterans and their families. The various hosts organized gallery talks by Cousino, lectures by scholars on related topics, film presentations, musical concerts, and more. After the New York state tour was complete, the Vermont Folklife Center in Middlebury and the gallery at the Living/Learning Center at the University of Vermont in Burlington (an art therapy program) invited TAUNY and Cousino to take the same exhibition to their sites in 1990, and the results were similar.

Because of the local publicity generated by those exhibitions, Cousino was asked to do interviews for radio and television stations in several cities, and feature articles appeared in numerous local newspapers. National attention was directed to him and his artwork by a feature in October 1990 in *Life in the Times,* a supplement to the newspaper *Army Times,* which is distributed to millions of active members of all branches of the American military. In

the fall of 1989, the entire issue of the academic publication *Journal of American Folklore* was devoted to the folk expressions of Vietnam veterans. My article about Michael Cousino, entitled " 'These Aren't Just My Scenes': Shared Memories in a Vietnam Veteran's Art," was included.

Over the last ten years, his life has taken several different turns. Cousino, with encouragement from a branch unit of Mater Dei College in Gouverneur, completed an associate's degree in 1987 and one week later was employed as a Disabled Veterans Outreach Programs (DVOP) Specialist, a job he calls "a dream come true." During the last seven years, he has traveled widely in his region of New York for the state department of labor, helping dozens of disabled as well as able veterans with personal and job-related problems. He makes employer contacts to advocate for job opportunities for veterans and informs and assists veterans in applying for positions.

After living for several years in a small mobile home at the edge of the village of Gouverneur, in 1993 he and his family purchased a home of their own about ten miles from town. Formerly a deer hunting camp, it was built by a Vietnam veteran friend who had died a couple of years before the Cousinos bought it from his estate. They have made progress in remodeling it and are happy to have land and a home of their own. In addition, he

Michael Cousino talking with Korean War veteran at 1987 exhibition opening at Roberson Center in Binghamton (Photo by Varick A. Chittenden/ TAUNY)

Michael (senior), Matthew, Michelle, Michael (junior), and Patti Cousino at home, 1994

now has adequate, well-lighted space in which to work on his scenes.

Even the news from Mike's doctors in the spring of 1987 that his physical condition had so deteriorated that he would have to use a wheelchair for the rest of his life has not deterred him. His fatalism and a genuine determination serve to make the best of the situation. He is proud of the new nickname "Wheels," given him by his veteran friends and used by dozens of his clients at work. He sees it as a "badge of courage" and another form of encouragement to those still struggling. A steady flow of Vietnam veteran friends in and out of their home, either conducting business or socializing, illustrates how far they've all come in a short time.

As for future art work, Cousino maintains that there are many more pieces that he can do:

**Our story is not told yet. I still want the kids in this country to know what went on there. Movies, TV, and books aren't really doing it. Until the story is told, until the POWs and MIAs are home, I won't stop. As long as there are veterans willing to tell their story, I have subjects and I will do them.**

In fact, he has begun work on a major piece, the size of an office desk top, which will portray a complete battle scene, using the navy patrol boat story of his friend Bill as his source. He envisions other pieces that help to complete the story of the war, including one narrative from a Coast Guard veteran and another from the air force, the two branches he has yet to illustrate. And he still is trying to develop two that are very important to him, one about his visits to the Vietnam memorials, and, especially, one for Patti, which includes her participation in some of his veterans' activities.

## Cousino as Inspiration

While his original goals in creating scenes were personal satisfaction and group affirmation, it was not long after his decision to put his artwork on public display that he learned just how much his story and his efforts are an inspiration to others. From his first exhibition in Albany, he remembers two incidents that have been important to him in understanding this new role. From the opening reception he recalls this anecdote:

**There was one Vietnam vet that went across the gallery to grab his wife and dragged her through the crowd and said, "See that! Look at that! I burnt shit in Vietnam!" He was so proud that I depicted what he did, you know. His wife didn't know what to say, but he kept saying, "Look at this! Look at this!" That impressed me. That job was very common. In the first thirty days, new guys [like me, in that scene] were put on work details and burning shit was one of the worst.**

Veteran friend Mike McCurdy and Michael Cousino in Cousino's yard, 1994

Time and time again, Cousino hears similar stories. Many veterans and their families who wouldn't ordinarily go to art museums or college art galleries turn out for the exhibitions of his work and, more often than not, will start to discuss with him in detail certain pieces that resonate with them. He is especially fascinated and pleased with the number of veterans who have identified themselves to him and said that they ordinarily do not talk about their experiences at all. He remembers one incident in particular:

**When a lady—her name was Pat, I think—walked up to me and said, "I am a Vietnam vet," I looked her in the eyes and said, "Welcome home, sister," and gave her a big hug. Yes, this is one of my reasons why I must keep the Vietnam experience alive. This lady for twenty-three years hid the fact that she is a vet. My art show in Buffalo, 1989, brought her out of the closet. We went out to my jeep and drank a few beers and just kicked back and talked. Soon, fifteen or so other vets joined us. Damn, that felt good! I am very happy to be the catalyst to reach this Vietnam veteran. Maybe more of my brothers and sisters will come home. It just makes me feel good knowing that I helped in some way!**

Another memorable, confirming incident for Cousino also occurred at the Albany opening. Retired United States Army Maj. Gen. Robert B. Adams, now Commissioner of the New York State Office of General Services, which administers the New York State Vietnam Memorial where the dioramas were being shown, attended. General Adams had himself served in combat in Vietnam. Cousino who met him in the gallery, recalls:

**What impressed me was the two-star general. Like the way we're talking, that's how he addressed me. We had a normal conversation. It wasn't like "Sergeant to God," and like God came there. A two-star general? Wow! He said that my art was very realistic, and that impressed me because it came from somebody that called the shots, where he could look at it and feel what the private felt.**

In addition to the artwork and his job, Mike Cousino devotes much of his limited spare time to working in other ways with veterans' affairs. Since the first informal veterans' meeting in the North Country in 1983, at least two groups—Dragon House in Watertown and LZ (Landing Zone) Freedom in Gouverneur—have been created as "social rap groups." Cousino and Patti, along with numerous other individuals and couples, have participated in their activities, often in leadership capacities. In the early days of the groups, especially, there was plenty of interaction, with parties and dances and other social functions. Families became friends in a few months'

time. One memorable experience for these local veterans was a bus trip in 1984 to Washington, D.C., for Veterans Day ceremonies; their first visit, it was a very emotional time for all of them. Three years later, Cousino joined another group from the North Country for another trip to Washington for Veterans Day. During that visit, he was inspired to write a poem he called "Eternal Flame," which he dedicated to the dead and missing of that war. His poem was published in his college literary magazine later that academic year

In the summer of 1989, under the cochairmanship of Mike Cousino, the Vietnam Veterans Moving Wall Memorial was brought to the St. Lawrence River village of Massena. The Moving Wall is one of three, half-size replicas of the Washington memorial that were built to travel to small towns and cities all over the United States. The purpose is to serve the veterans and families who are unable or have chosen not to meet the physical and emotional challenges of going to the real thing. With the help of the mayor of the village, Cousino organized a full week of activities: band concerts, prayer services, parades, Mohawk Indian ceremonial dances, a candlelight vigil, a "USO Show" with a disc jockey and songs of the Vietnam period, and two solemn ceremonies with a variety of speakers to open and close the week. Over fifty thousand people came to the site in those seven days. Cousino was elat-ed at the responses the memorial elicited. He met hundreds of veterans from his area, several of whom actually told him that this was their first time "out."

Because of the success of that visit, some people from Watertown, a small city forty miles west of his home town, began to plan similar activities around the Moving Wall for 1991. This time Cousino was an adviser, but he actually organized his own LZ Freedom group to walk the distance from Gouverneur to Watertown for the opening ceremony. The group sought to promote attendance at the site and to bring public attention to the plight of POWs and MIAs. While Cousino operated his wheelchair and dozens of others walked with him along the state highway, many people cheered them on. Newspaper and television coverage was plentiful, and huge crowds gathered for the next week at the temporary memorial site in Watertown.

Michael Cousino is a folk artist in ways that are both conventional and unusual. He has the self-taught skills of a sculptor and model maker. He is resourceful in salvaging found objects and materials and inventive in refashioning them into images that serve his specific needs. He has a prodigious memory for details about even the most ordinary of daily experiences. He is a superb storyteller, with a great sense for point of view and dramatic moments,

which he translates into carefully selected scenes in his art. And he uses his art not only to relive personal memories but also to share the stories with others.

Like many other folk artists, Cousino is carefully tuned into his community's values, concerns, and images. In his case, however, instead of just creating from his personal experiences for self-satisfaction, he actually submits his material to the folk community of fellow veterans for their reactions and appraisal.

With his public acceptance as an artist, he takes great satisfaction in reaching out to others. Like some other contemporary folk groups, Vietnam veterans are widely dispersed in society. In fact, because of their particular histories, many have felt especially isolated for many years, not only from the rest of the world but from each other. Cousino welcomes the opportunities to speak at exhibition openings or in gallery tours, where he meets veterans who almost immediately start swapping stories. There is an intensity in the narration and in the jargon that feeds on itself. He is constantly hearing new stories from his latest contacts that he wants to turn into artworks. Cousino gives us the rare opportunity to see the real process of folk art creation.

Finally, with his insistence on precision of detail—in anatomy, costume or uniform, equipment, and landscape, for example—he objectifies personal experience narra-tives into three-dimensional photographs, frozen in time. Unlike the fine artist who purposely takes license to interpret, even distort, reality, and unlike many memory artists who rearrange details for convenience or because of lack of skill, Cousino is obsessed with accuracy. Even though nearly thirty years have passed since the actual events were experienced, he feels relieved and rejuvenated by the retelling of these episodes with such exactness. The more he works, the more skilled he becomes; the more skill he has, the more true to life the stories are. And making true stories is his goal.

## References

Ames, Kenneth. 1977. *Beyond Necessity: Art in the Folk Tradition*. Wilmington, Del.: The Winterthur Museum.

Barrett, Didi. 1985. "Commentary on Memory and Memory Art." In *A Time to Reap: Late Blooming Folk Artists*, 4–5. South Orange, N. J.: Seton Hall University.

Beck, Jane, ed. 1982. *Always in Season: Folk Art and Traditional Culture in Vermont*. Montpelier, Vt.: Vermont Council on the Arts.

_____. 1988. "Stories to Tell: The Narrative Impulse in Contemporary New England Folk Art." In *Stories to Tell*, ed. Lisa Weber Greenberg, 38–54. Lincoln, Mass.: DeCordova and Dana Museum and Park.

Becker, Jane S., and Barbara Franco. 1988. *Folk Roots, New Roots: Folklore in American Life*. Lexington, Mass.: Museum of Our National Heritage.

Bronner, Simon J. 1985. *Chain Carvers: Old Men Crafting Meaning.* Lexington: The University Press of Kentucky.

Butler, Robert N. 1969. "The Life Review: An Interpretation of Reminiscence in the Aged." In *New Thoughts on Old Age,* ed. Robert Kastenbaum, 265–66. New York: Springer Publishing Co.

Caputo, Philip. 1977. *A Rumor of War.* New York: Ballantine Books.

Chittenden, Varick A. 1982. *Found in New York's North Country: The Folk Art of a Region.* Utica N.Y.: Munson-Williams-Proctor Institute.

_____. 1989. "'These Aren't Just My Scenes': Shared Memories in a Vietnam Veteran's Art." *Journal of American Folklore* 102 (October-December): 412–23.

Dorson, Richard M. 1959. "G.I. Folklore." In *American Folklore,* 268–76. Chicago: The University of Chicago Press.

Edelman, Bernard, ed. 1985. *Dear America: Letters Home from Vietnam.* New York: Pocket Books.

Ellison, Ralph. 1964. "Richard Wright's Blues." In *Shadow and Act,* 77–94. New York: Random House, Inc.

Glasser, Ronald J. 1980. *365 Days.* New York: George Braziller.

Hemingway, Al. 1994. *Our War Was Different: Marine Combined Action Platoons in Vietnam.* Annapolis: Naval Institute Press.

Herr, Michael. 1977. *Dispatches.* New York: Avon Books.

Hufford, Mary, Marjorie Hunt, and Steven Zeitlin. 1987. *The Grand Generation: Memory, Mastery, Legacy.* Washington, D.C.: Smithsonian Institution Press.

Jones, Michael Owen. 1989. *Craftsman of the Cumberlands: Tradition and Creativity.* Lexington: The University Press of Kentucky.

_____. 1987. *Exploring Folk Art: Twenty Years of Thought on Craft, Work, and Aesthetics.* Ann Arbor: UMI Research Press.

Karnow, Stanley. 1983. *Vietnam: A History.* New York: The Viking Press.

Kirshenblatt-Gimblett, Barbara. 1987. "Authoring Lives: Life History as Cultural Construction/Performance." Paper presented at Third American-Hungarian Folklore Conference, August, in Budapest.

Metcalf, Eugene W., Jr. 1986. "Which Folk? The Problem of American Folk Art." *Maine Antiques Digest* (April) 34-A–35-A.

Stewart, Susan. 1984. *On Longing: Narratives of the Miniature, the Gigantic, the Souvenir, the Collection.* Baltimore: The Johns Hopkins University Press.

Toelken, Barre. 1979. *The Dynamics of Folklore.* Boston: Houghton Mifflin Company.

Vlach, John Michael, and Simon J. Bronner, eds. 1986. *Folk Art and Art Worlds.* Ann Arbor: UMI Research Press.

Field notes and tape-recorded interviews with Michael D. Cousino, Sr., on September 18, 1986; June 23, 1987; and July 10, July 22, and August 15, 1994, greatly contributed to my understanding of his life and his art. Recordings and related information will be contributed to the archives of Traditional Arts in Upstate New York in Canton, New York. I have also used information from several informal (unrecorded) interviews and conversations with Cousino over the years. In addition, I have referred to notes from telephone interviews with Nellie Coakley (September 19, 1986) and Michael McCurdy (August 21, 1987) and personal letters from Elizabeth Kahn (October 12, 1987) and Ernest Amabile (November 28, 1987).

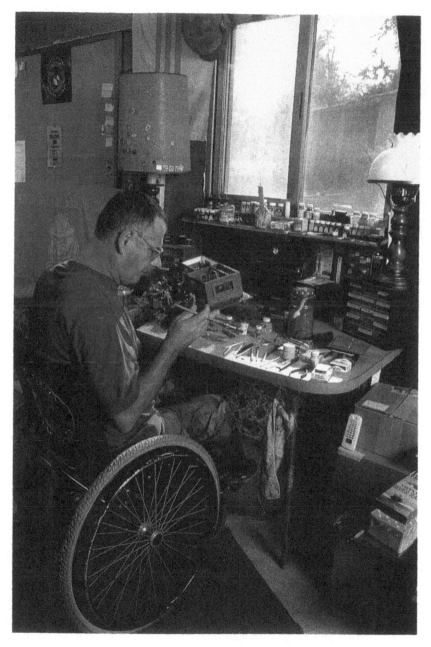

PLATE 1
Michael Cousino in his
home workshop, 1994

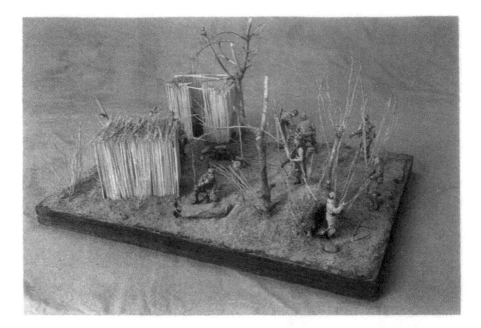

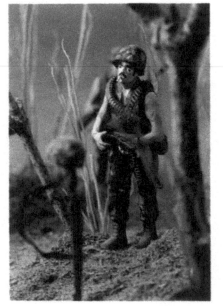

PLATE 2
*Daily Job of a Grunt*

PLATE 3
Self-portrait of Michael
Cousino, detail from *Daily
Job of a Grunt*

**38**

PLATE 4
*Malaysian Gate and Punji Pit*

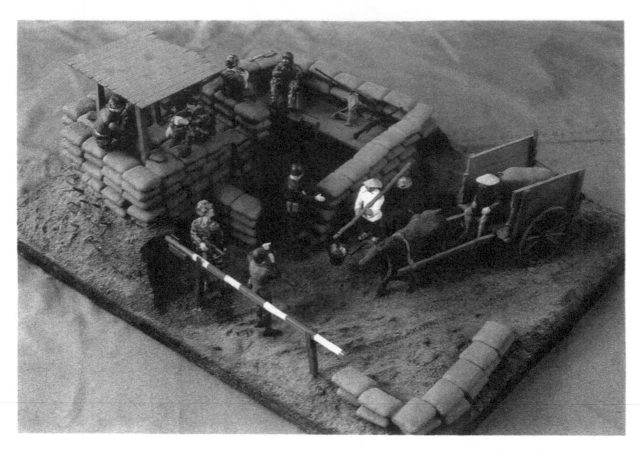

PLATE 5
*Checkpoint Charlie at an
American Fire Base*

40

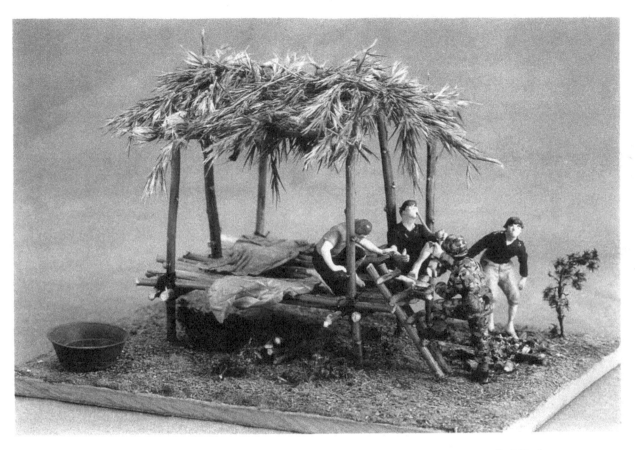

PLATE 6
*Interrogating Some
Montagnards*

**41**

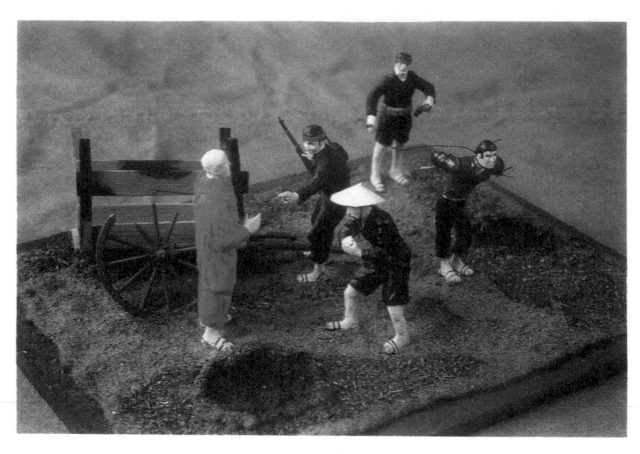

PLATE 7
VC Recruitment

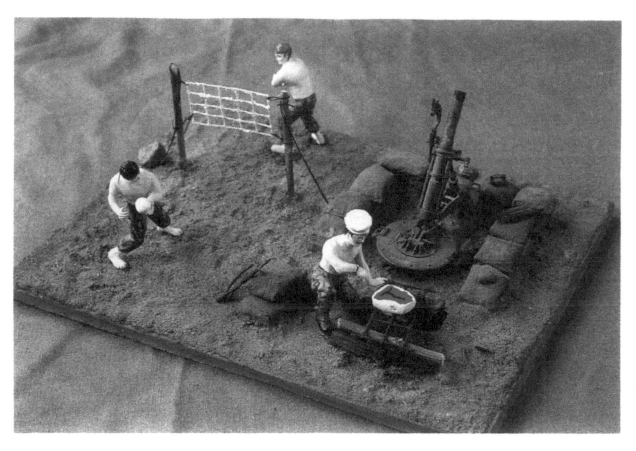

PLATE 8
*Organized Grab Ass*

43

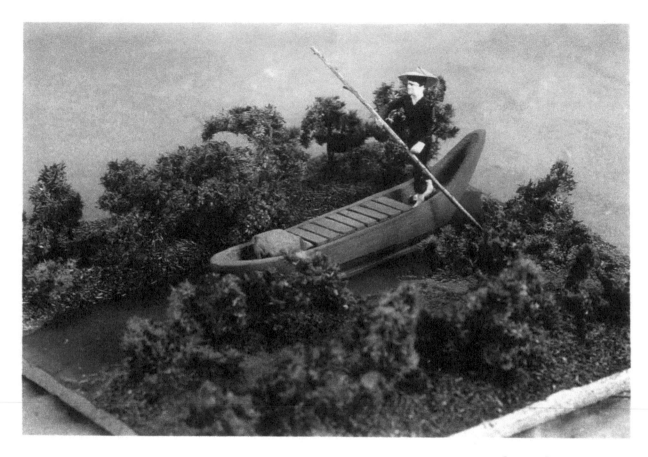

PLATE 9
*Friend or Foe? You Be the*
*Judge*

44

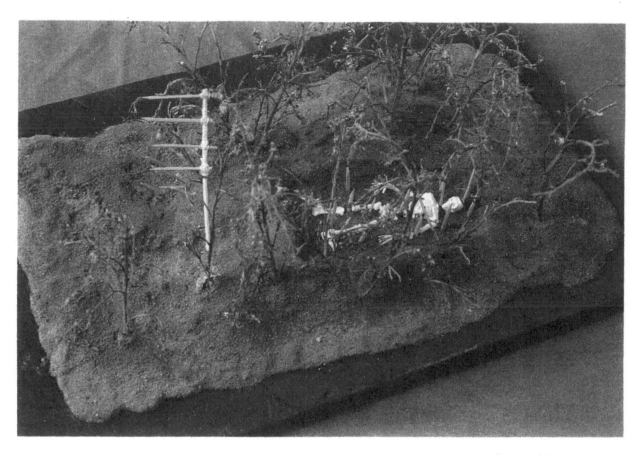

PLATE 10
Agent Orange

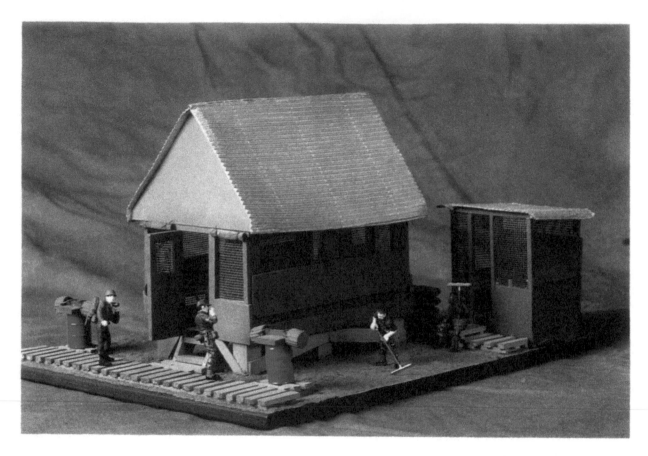

PLATE 11
*My Hootch at Red Beach or
An FNG's First Impressions of
Nam*

46

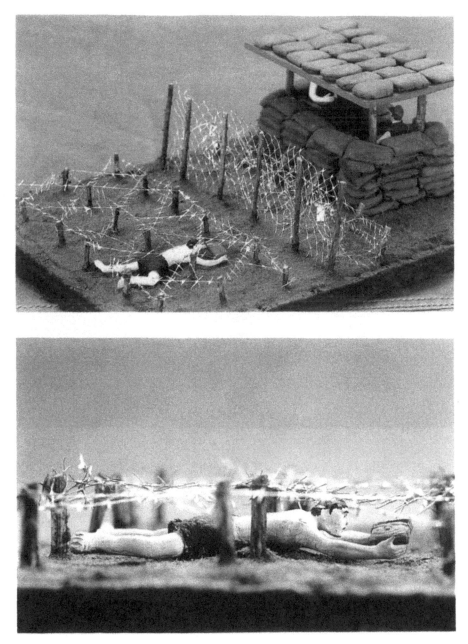

PLATE 12
*Zapper*

PLATE 13
Detail of Vietcong soldier
and satchel bomb from
*Zapper*

**47**

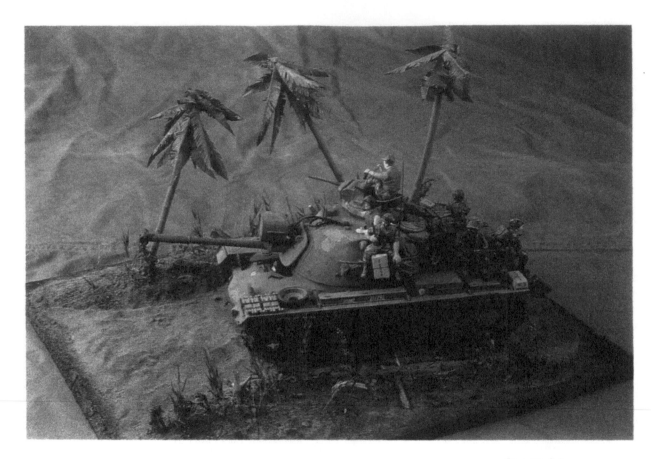

PLATE 14
*No Time to Stop to Pick the Flowers*

48

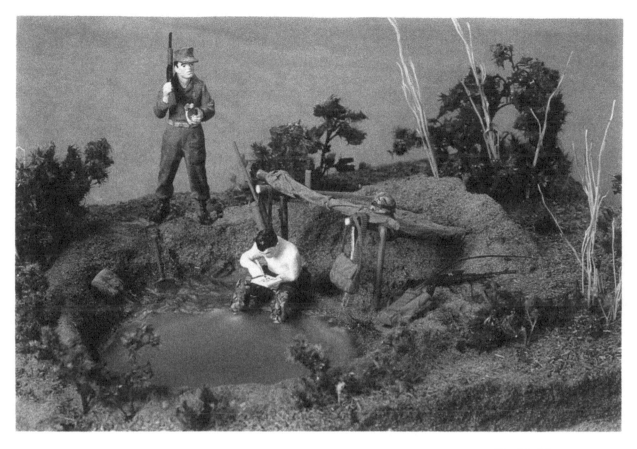

PLATE 15
*Camping Out in No Man's Land*

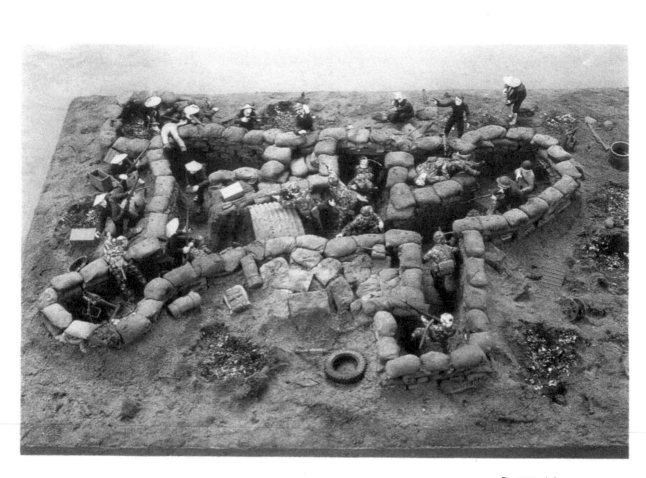

PLATE 16
*Being Run On: My Nightmare*

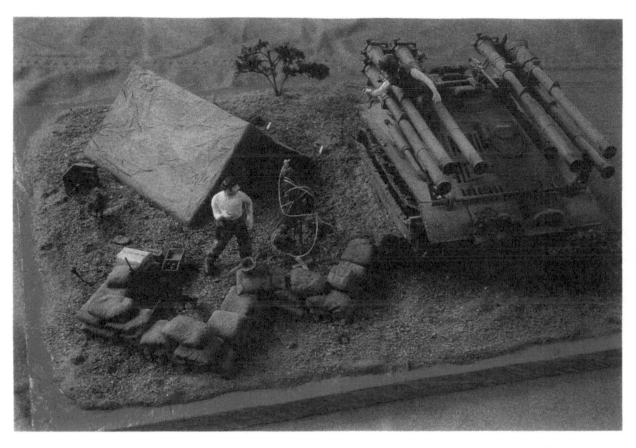

PLATE 17
*Christmas in Vietnam, 1968*

51

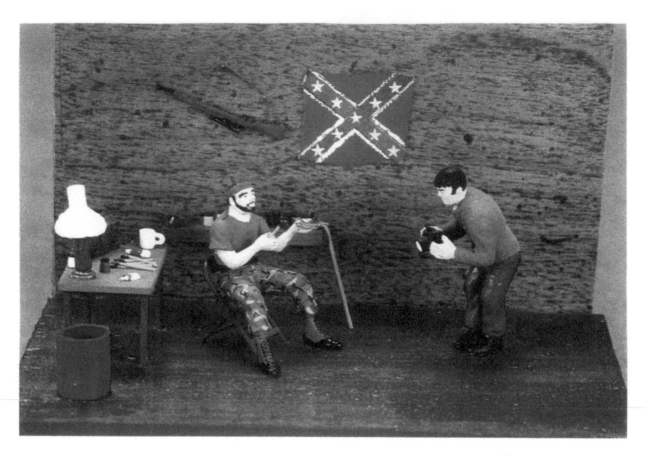

PLATE 18
*Our First Meeting: Folk Artist
and Folklorist*

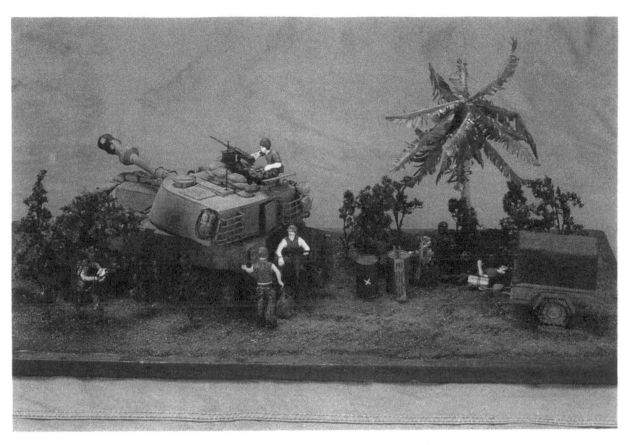

PLATE 19
*The Set Up*

53

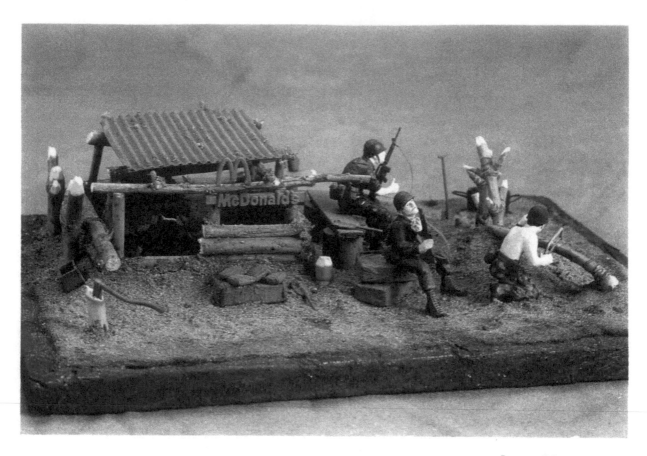

PLATE 20
*Mac-donald's in the Field*

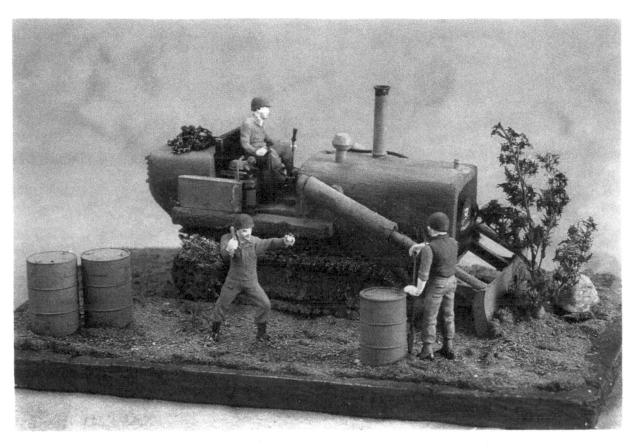

PLATE 21
*We Can Build and We Can Fight*

55

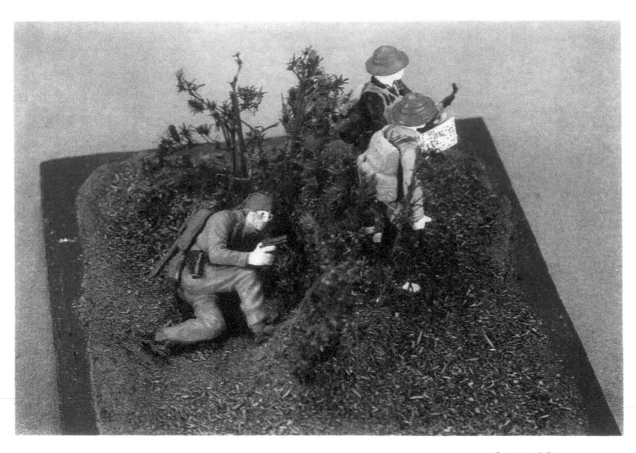

PLATE 22
*Forward Observer*

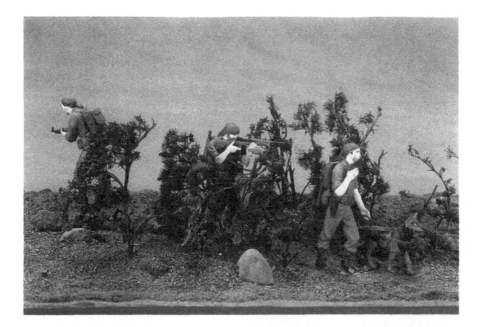

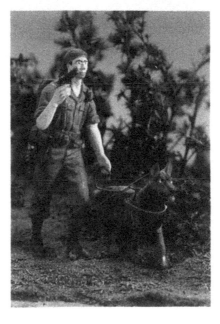

PLATE 23
*Snoops and Poops*

PLATE 24
Detail of Marine dog handler and his dog from
*Snoops and Poops*

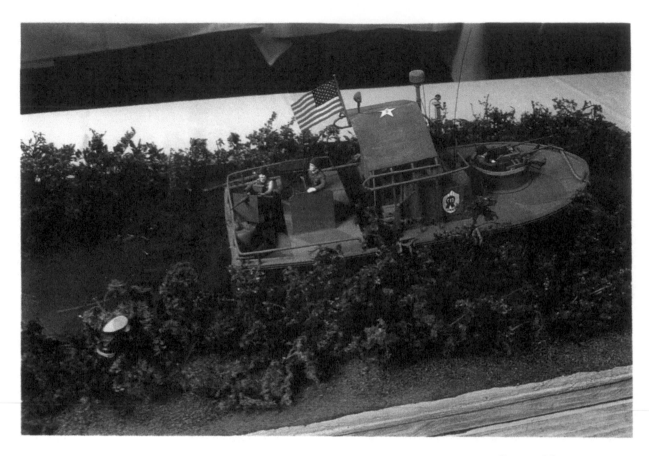

PLATE 25
Detail from *Up on Step, PBR*

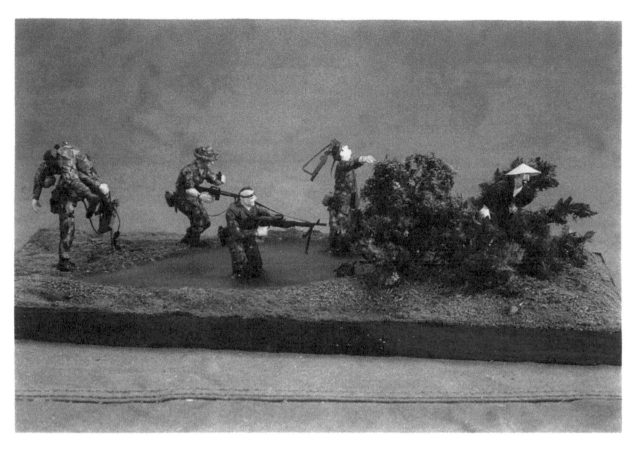

PLATE 26
*Seal Team Ambush*

PLATE 27
*Low Level Hell*

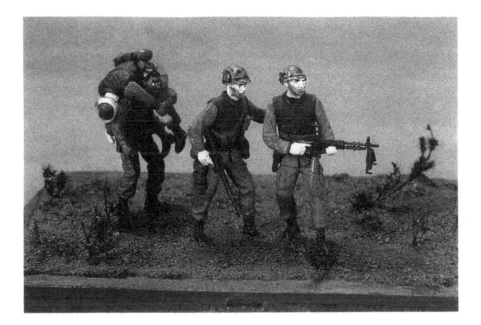

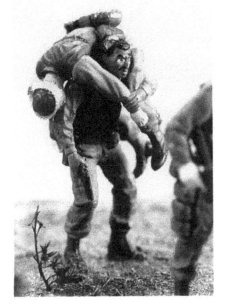

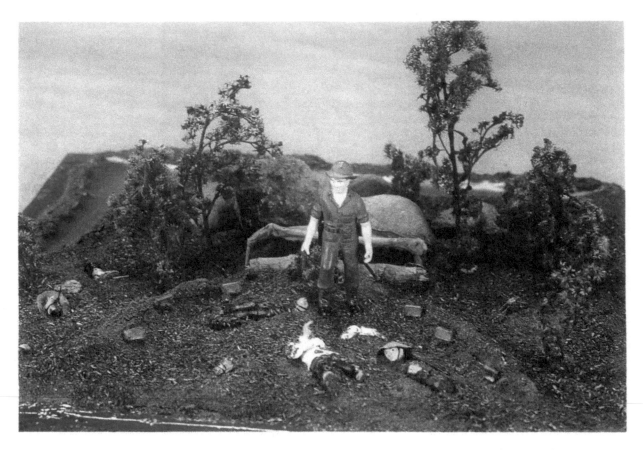

PLATE 30
*What the Dark Hides: The Morning After*

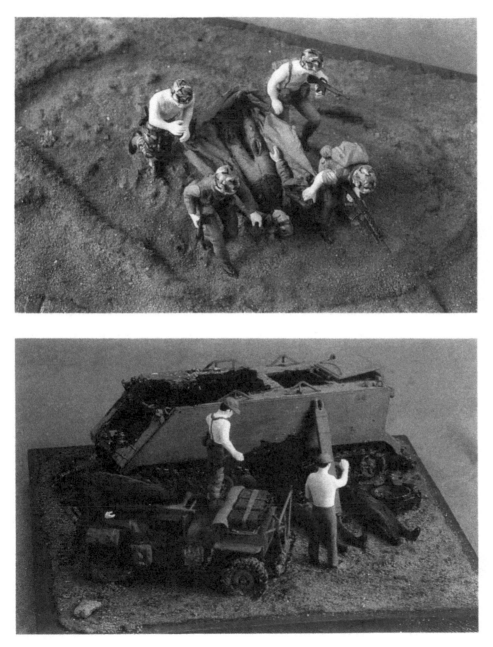

PLATE 31
*Medevac: Getting a Free Ride*

PLATE 32
*Death Comes to Us All*

63

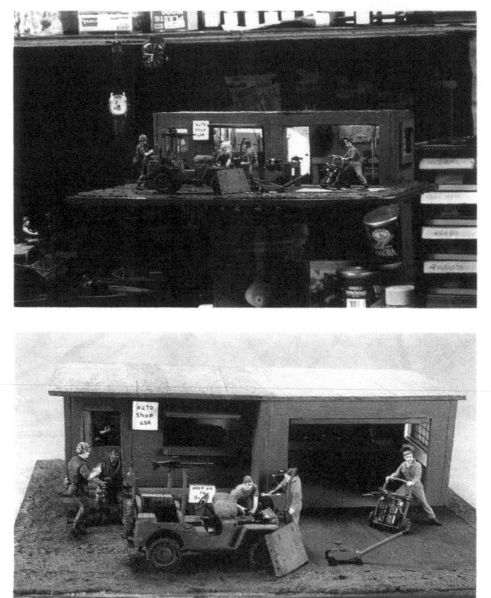

PLATE 33
*Auto Shop, USA*, on Michael Cousino's work desk at home

PLATE 34
Detail from *Auto Shop, USA*

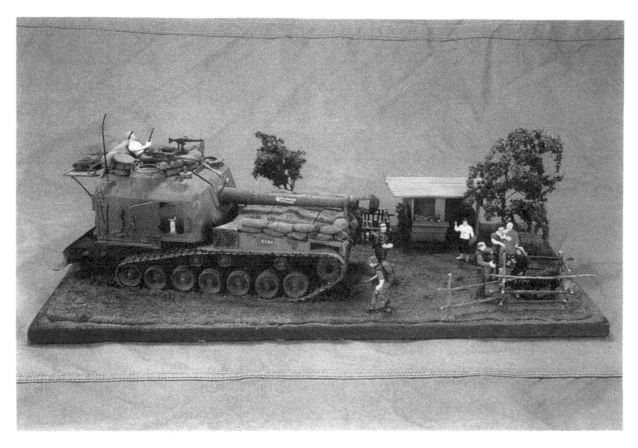

PLATE 35
*The Country Store*

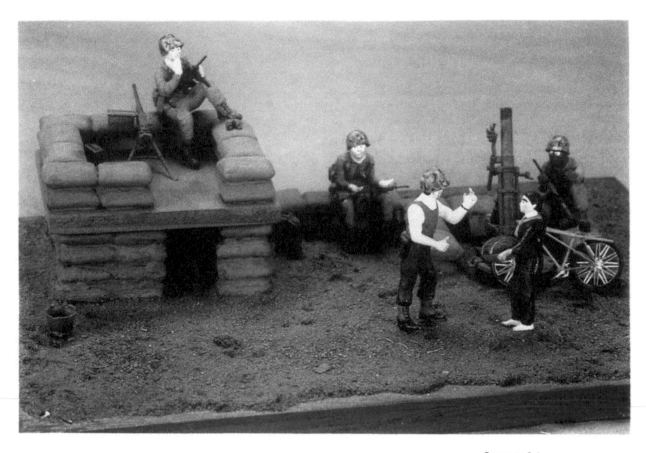

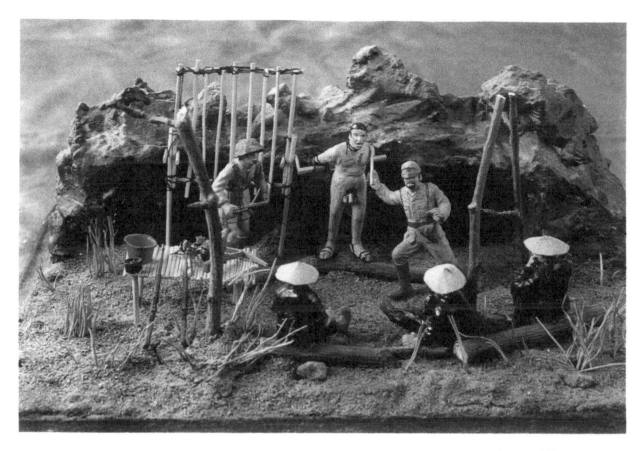

PLATE 37
*Don't Forget Us, the POWs*

67

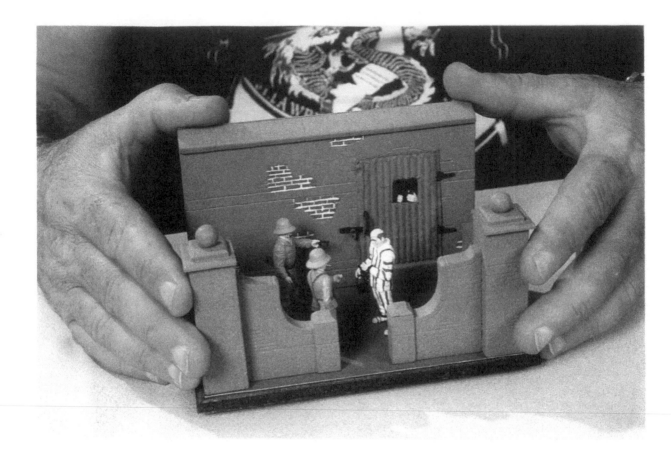

PLATE 38
Michael Cousino holds
*Twenty Years Later and We're
Not Home Yet! Why?*, showing
scale of the piece.

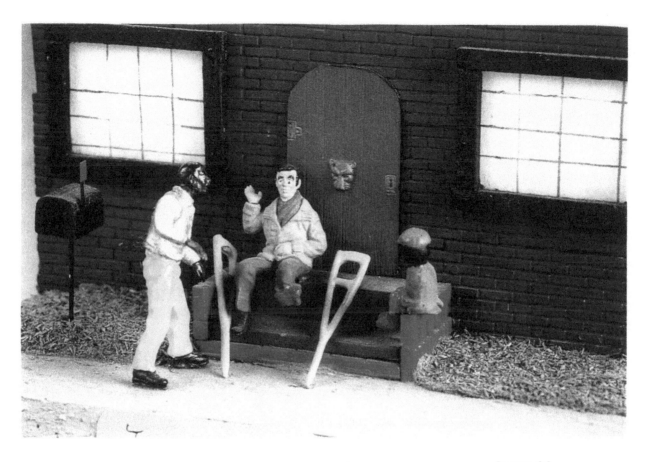

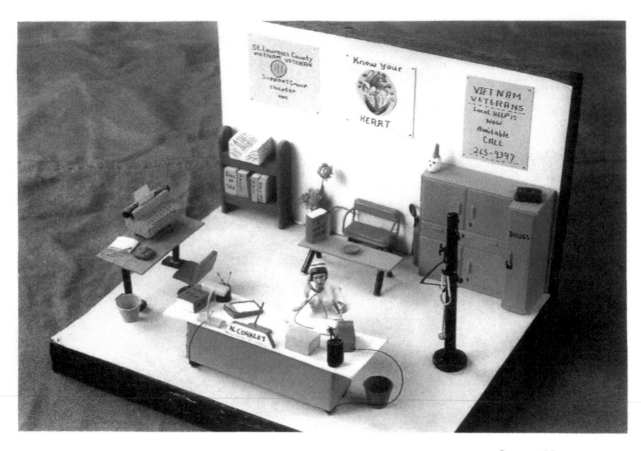

PLATE 40
Nellie, Our Group Counselor

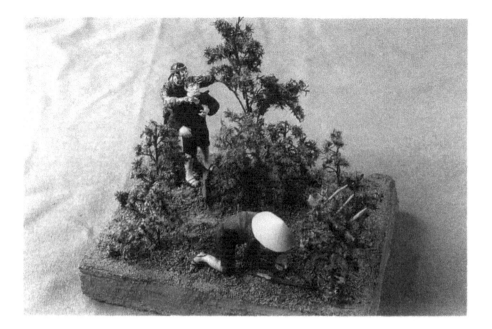

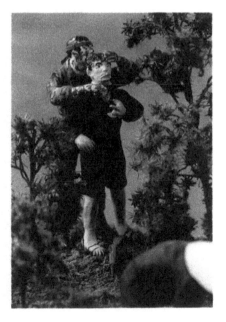

PLATE 41
*Taking Out a Sentry*

PLATE 42
Detail from *Taking Out a
Sentry*

71

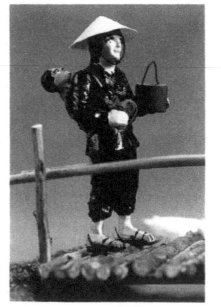

PLATE 43
Detail of *Joy Ride*, self-portrait of Michael Cousino on motorcycle

PLATE 44
Detail of *Joy Ride*, Vietnamese woman and child on footbridge